Streetwise

by Doug D'Elia

Streetwise

Copyright © 2016 by Doug D'Elia
Book Layout by: Marlee Delia

All rights reserved. No part of this book may be reproduced in any form by any electronic or mechanical means including photocopying, recording, or information storage and retrieval without permission in writing from the author.

ISBN-13: 978-1-329-83089-9

www.dougdelia.com
Email: dougvandelia@gmail.com
: Doug Delia

Printed in U.S.A

To Dad

Streetwise is a collection of pictures taken with celestial permission, each image a calling to capture the tint of light in a microsecond of time. But photographs are not static, nor linear; they are memory, subject to change, to manipulation.

Poetry is the voice of image, its tone and nuance brings meaning and clarity limited only by imagination. In the making of Streetwise the pictures stood quiet and patient, but pictures can never remain mute, they demand a voice, and so I brought them words with a set tune – like a choir director positioning the tenors and baritones just so, with the hope that I might stumble upon David's secret chord.

I'm taking it to the streets, and I hope to see you there.

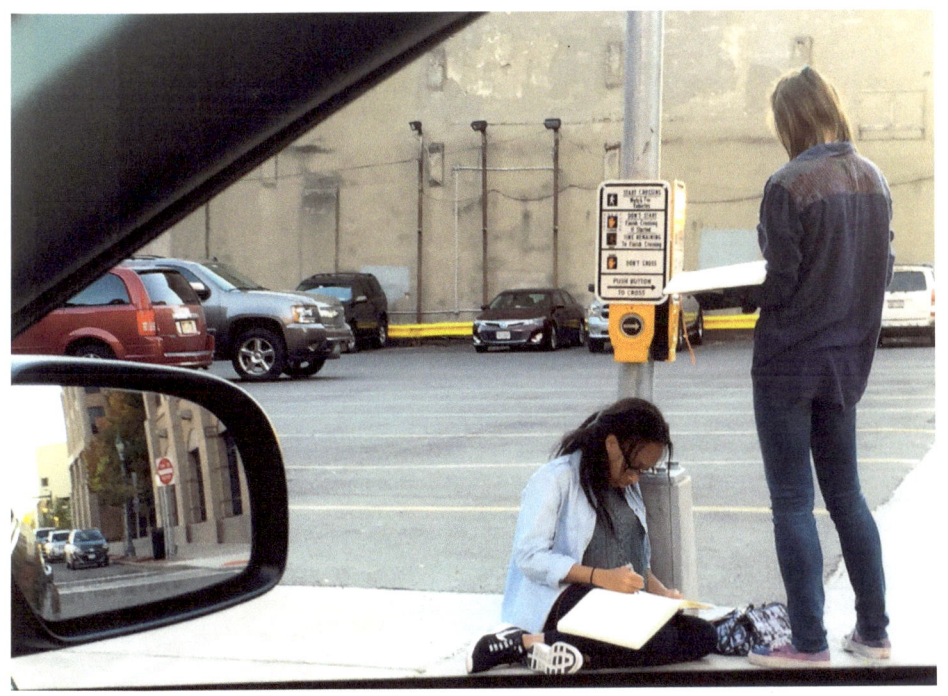

On occasion you catch people
in the act of Art - red handed,
so intent on capturing IT
they never realize you have them,
the skilled huntsman you are,
measured in the crosshairs.

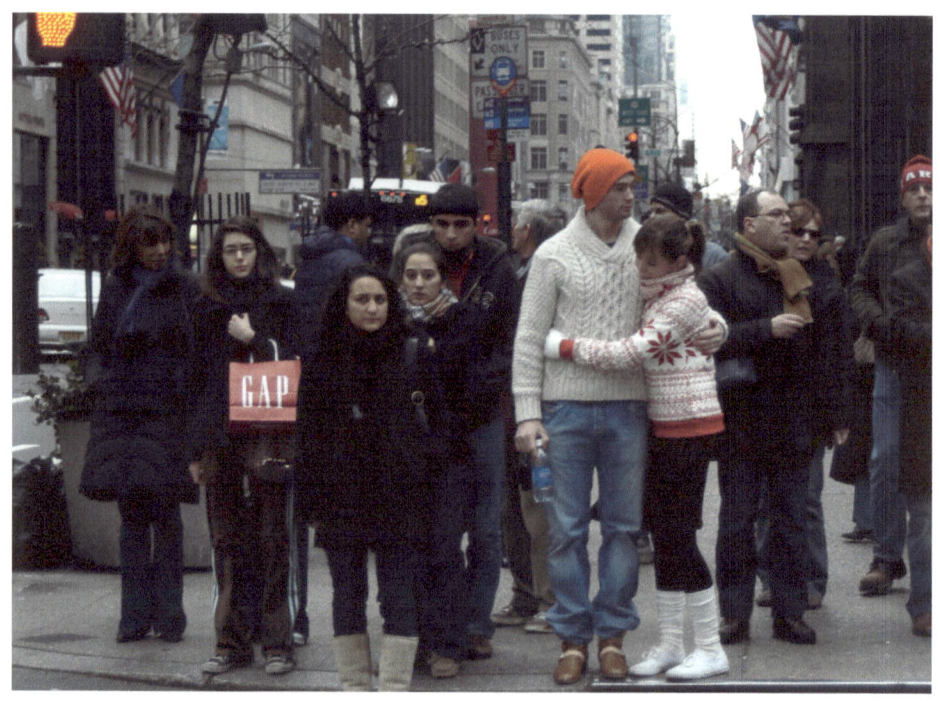

There is something unmistakable about LOVE.

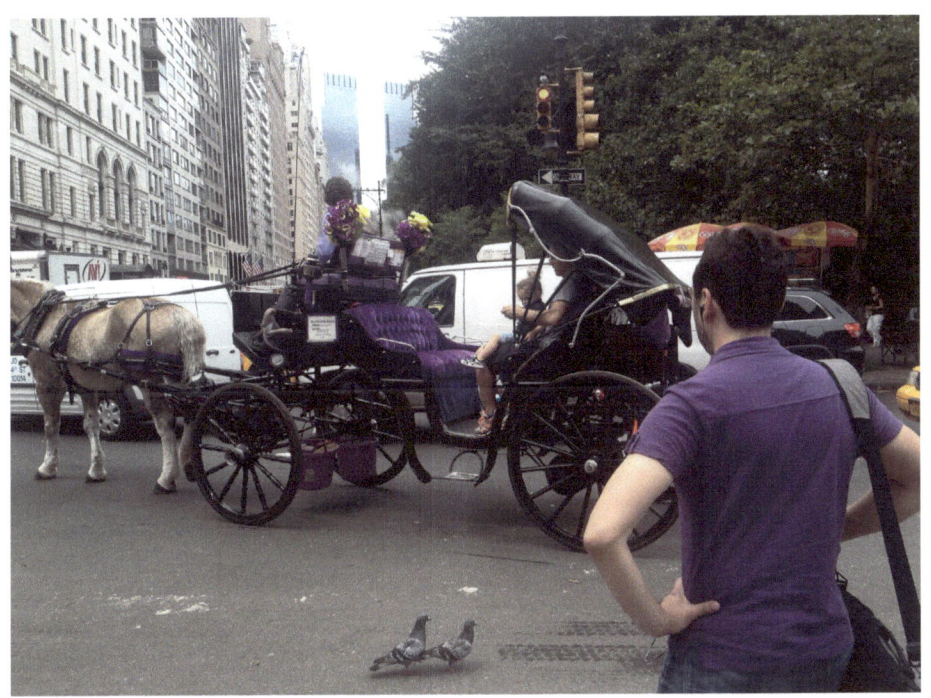

At first I thought it was about the color purple,
the man in the purple shirt that matched the color of the cab.
Then I thought it was a about a romantic horse-drawn
carriage ride around Central Park, but ultimately
it was about pidgins - two love birds heading off
to the park in search of bits of popcorn and sunshine.

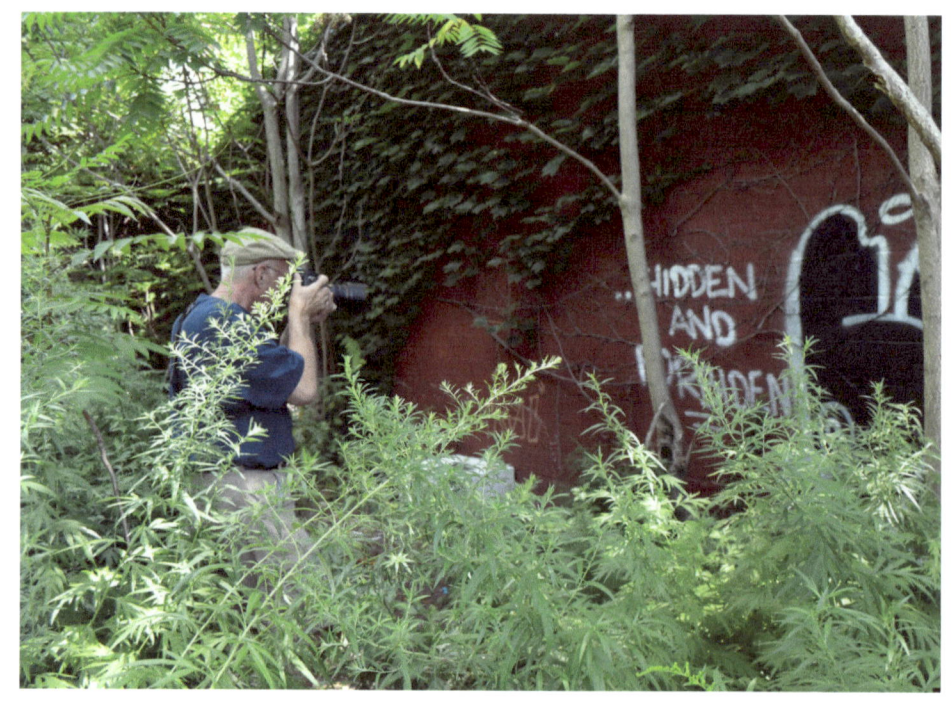

There is a power in words
waiting to be discovered,
and an anticipation
of the debate over
their meaning.

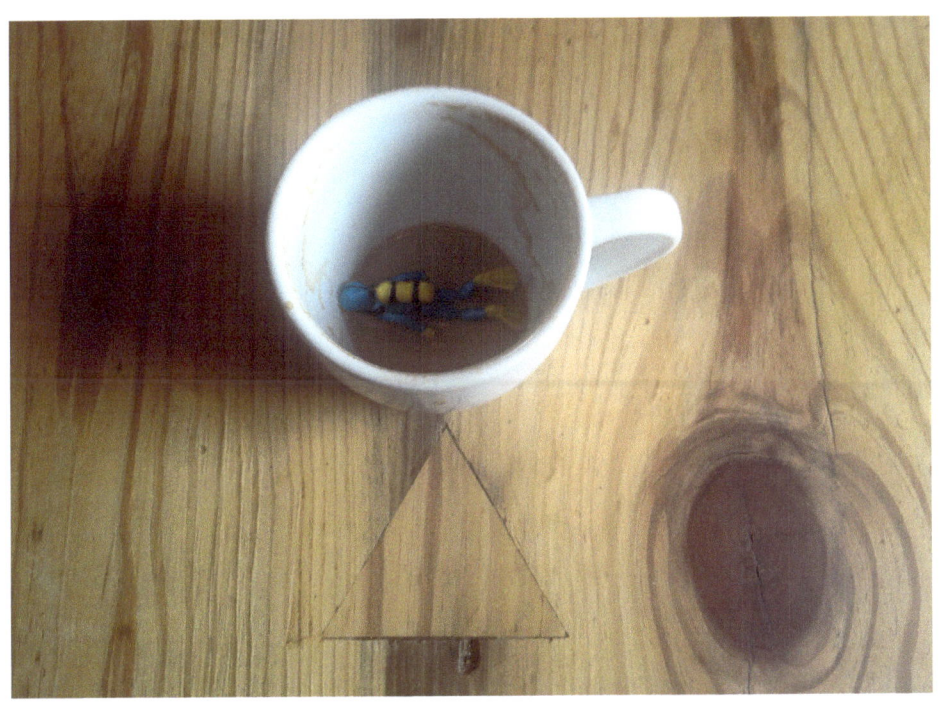

It's Sunday morning
the leaves turning crimson and gold
football or cross country season
depending on how fast or hard you play.
I'm content to go for a swim
circles over triangles.

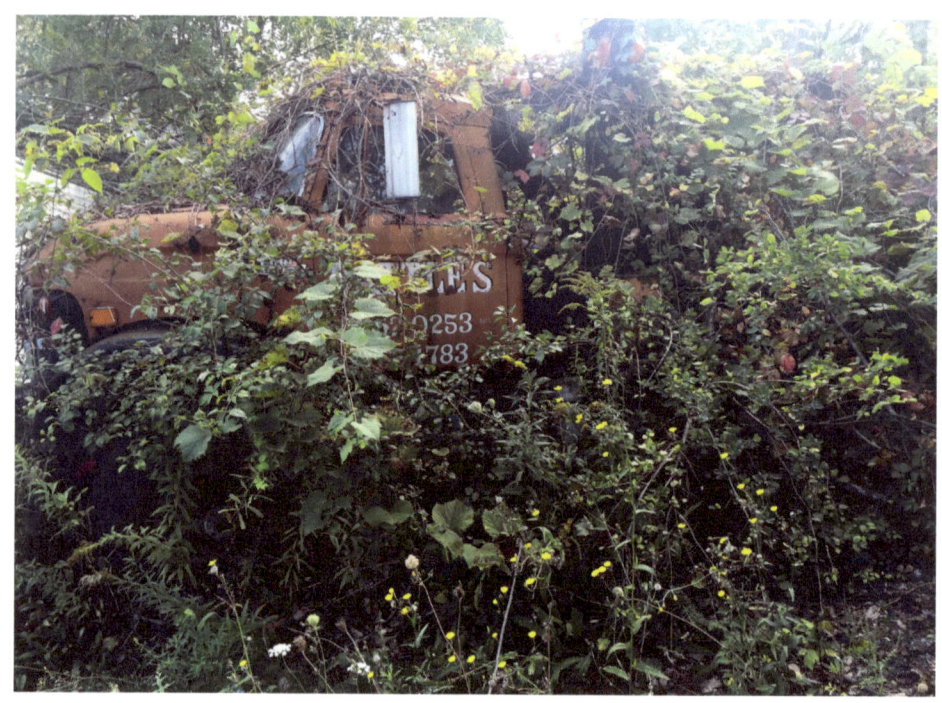

When our engine seizes-up,
our hinges turn copper, rust
and blemishes appear on our rear-view mirrors.
It is easier to feel that we have been put out to pasture
than to accept that Mother Earth Herself
has covered us in her bounty.

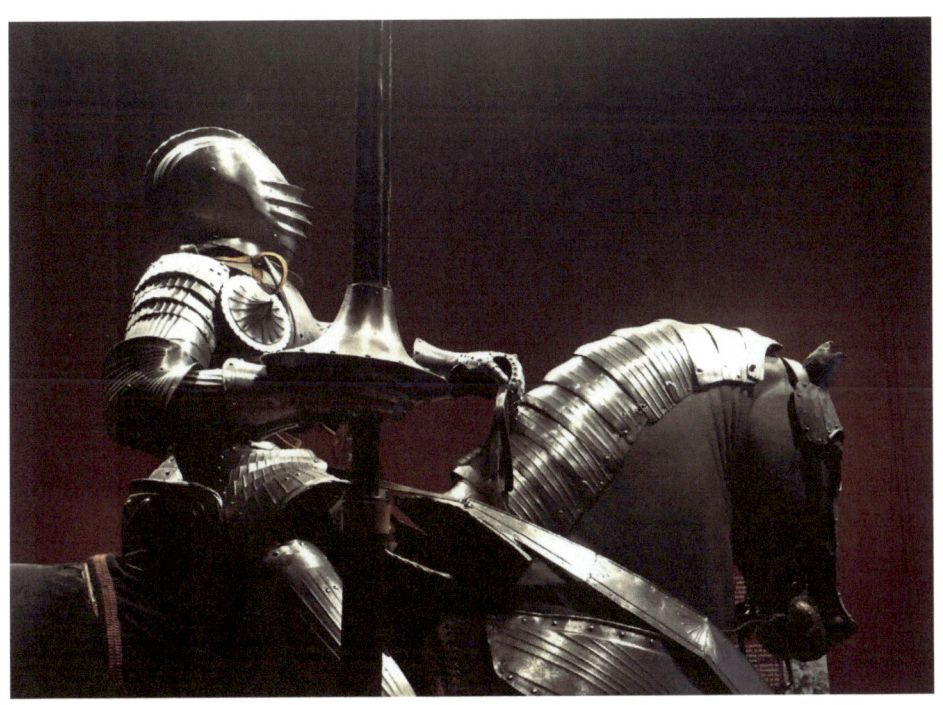

Is there a knight in shining armor in your life
or just another heartless tin man?

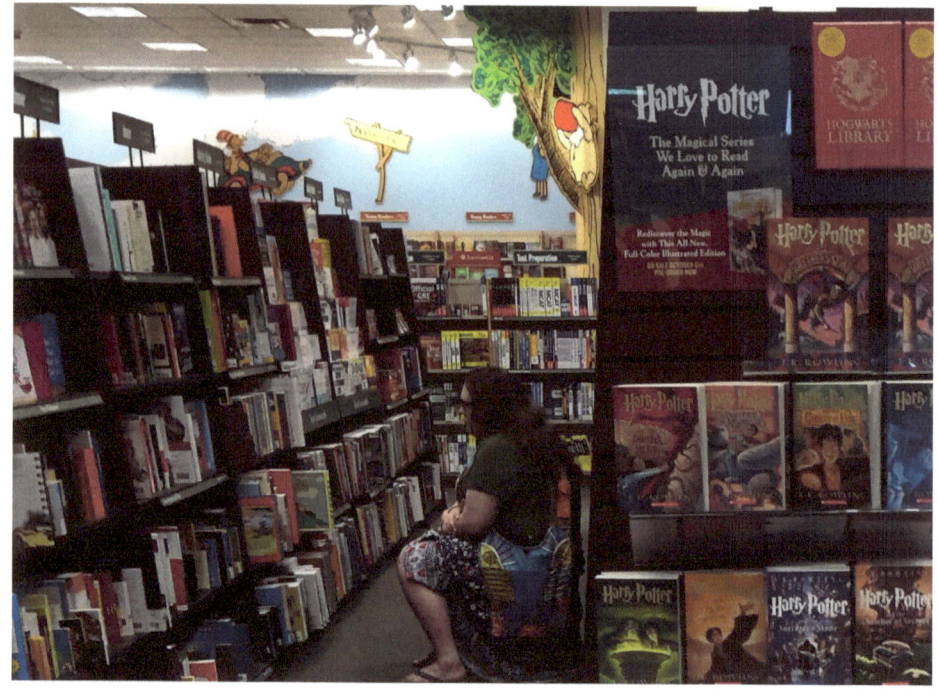

As long as young adults linger in the aisle of a bookstore there is HOPE.

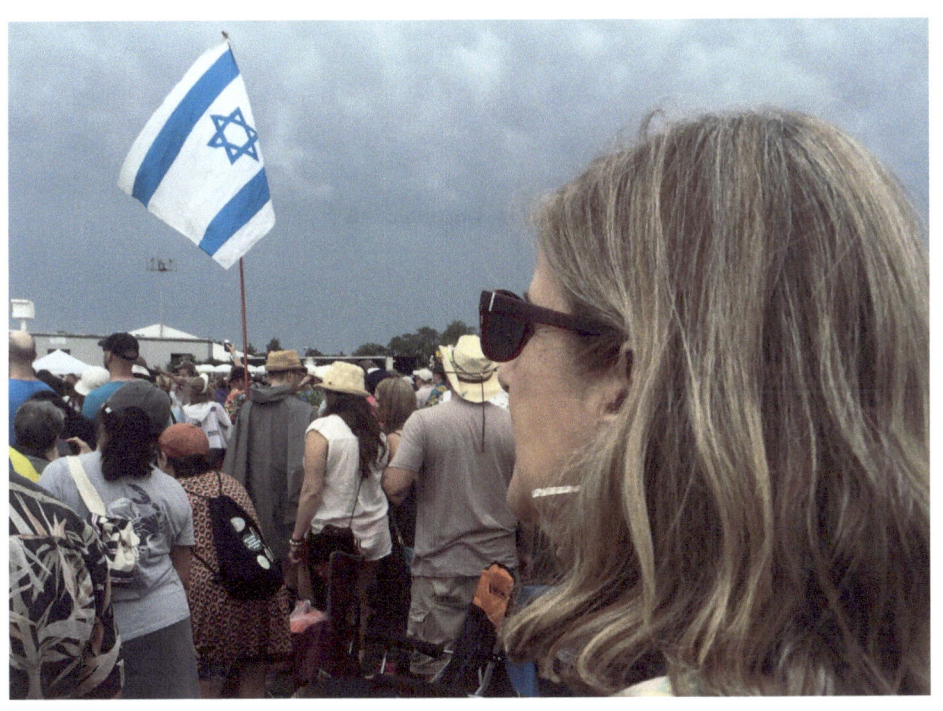

NY Times today:
Israeli's and Muslim's clash in Jerusalem,
refuges from Iraq and Afghanistan
seek refuge in Europe,
Saudis bomb Yemen,
Cairo is under siege,
civil strife in the Sudan,
Russian fighting in the Ukraine,
Mexican and So. American
families flee drug cartel violence,
another child dies in a drive by shooting.
in the City of Angels.
Is this not WW3?
Let's pray for PEACE.

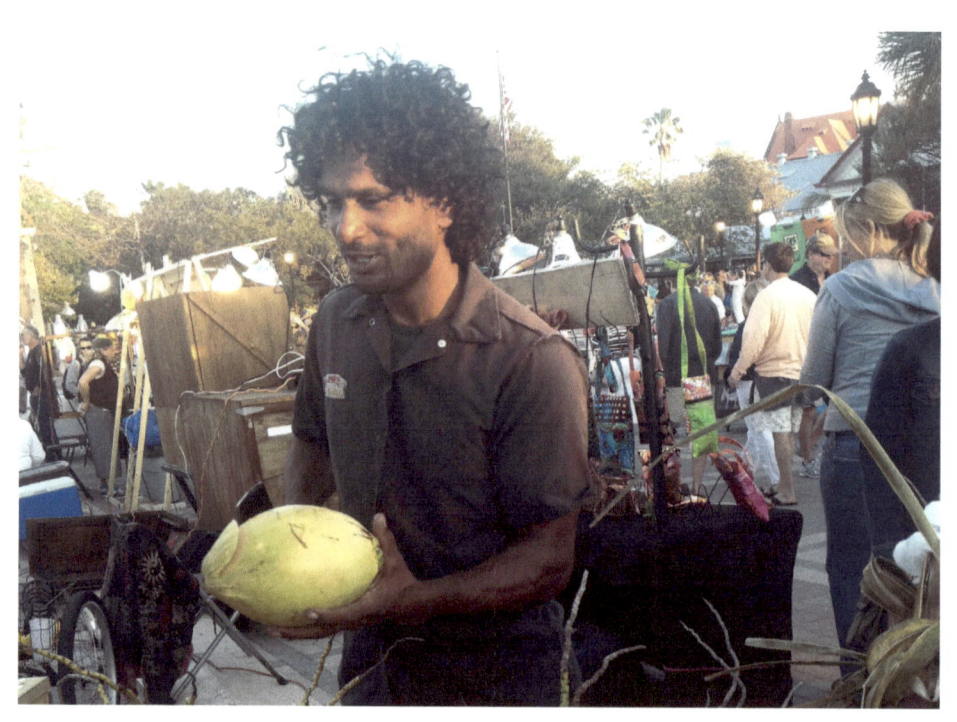

I asked the Island Man
IS THERE SOMETHING I CAN TAKE?
He said,
PUT THE LIME IN THE COCONUT AND SHAKE IT ALL UP.
Life should be as simple as that wonderful song.

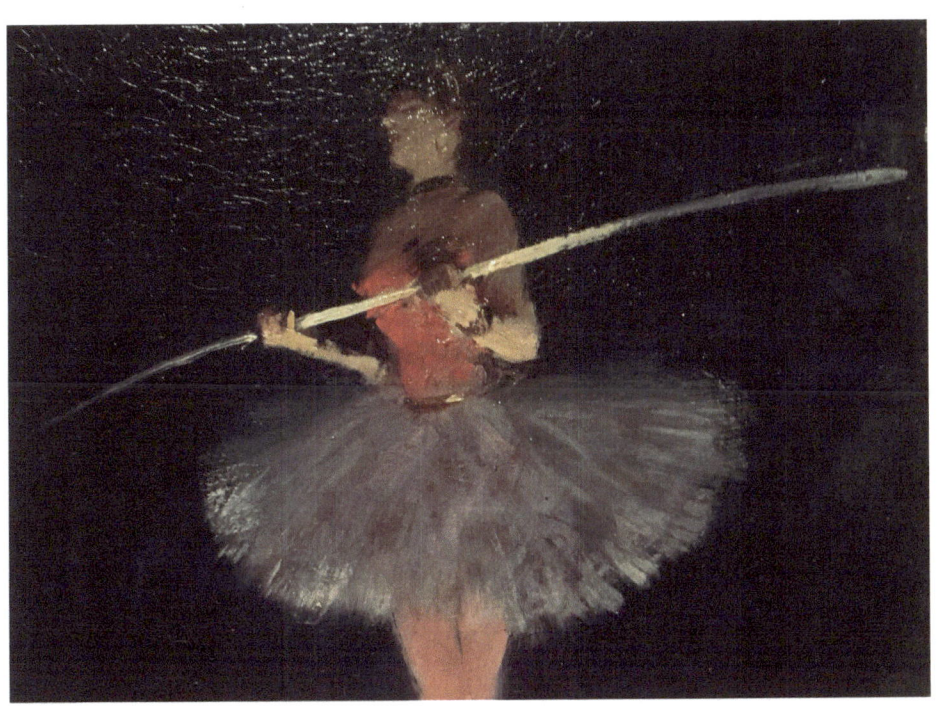

If I were married to you
would you expect me
to maintain perfect balance,
not a slip, even a tiny one?
And if I needed to let go
could I count on you
or would you let me
spiral downwards,
a free fall of sad eyes
and screaming lungs?

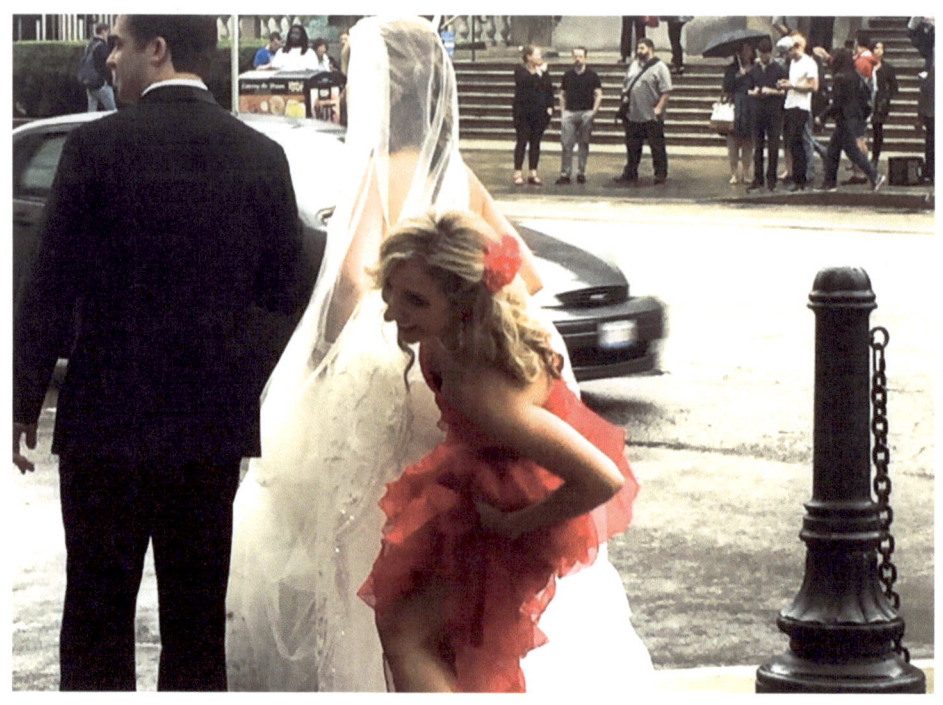

My first thought was wardrobe malfunction,
but the writer in me saw the tip of a small handgun.

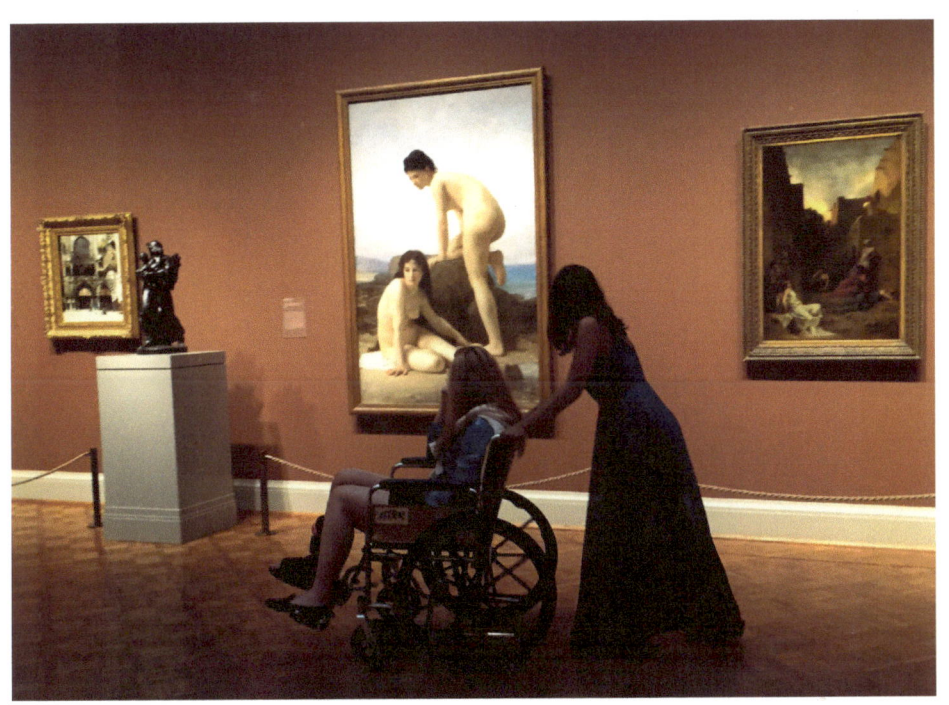

Regardless how interesting the art
I'm always distracted by the geometry
of the watchers.

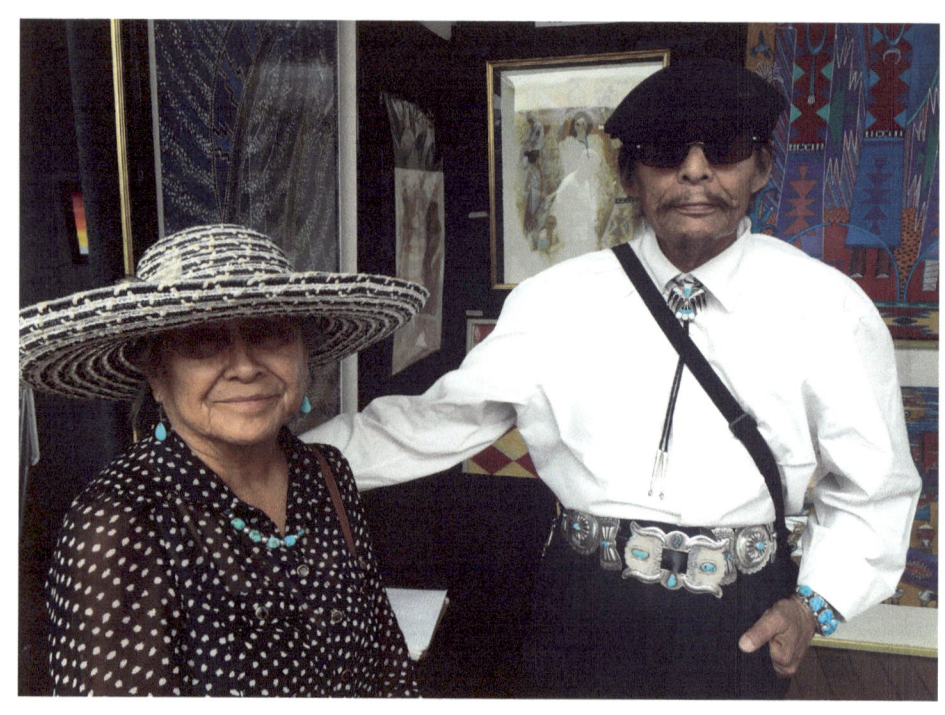

Do not fear growing old,
it's wonderful.
A life spent in preparation
of awakening - clarity
of thought, ideas, and wisdom.

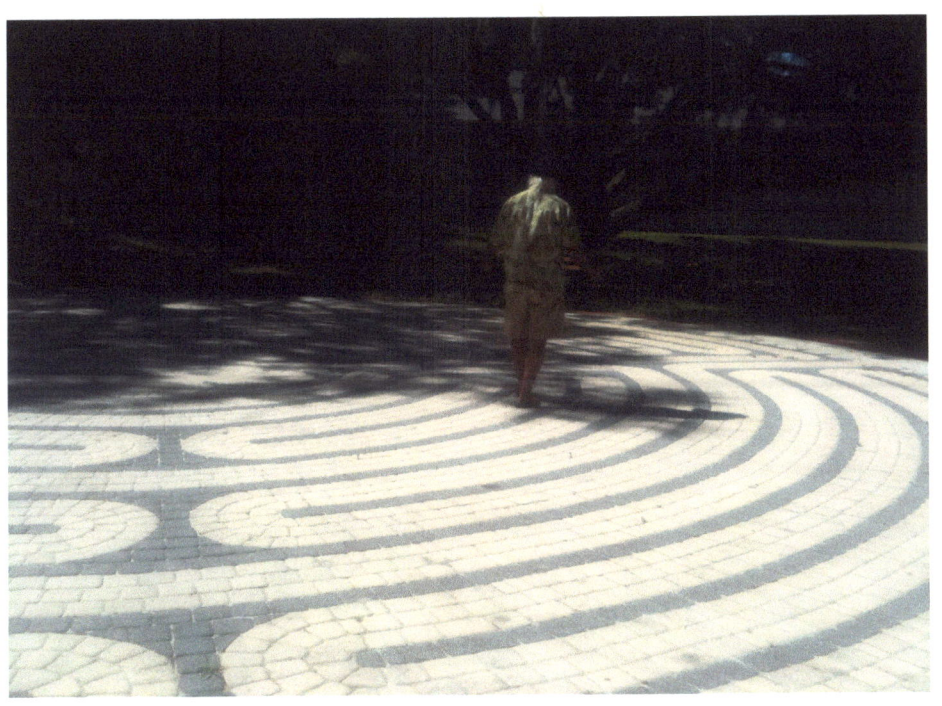

In a maze of geometry,
concentric circles lay.
The larger surrounding
the smaller,
The smaller completing
the larger.
And in a measured walk
upon mystic rings
that spiral inward,
the fractal traveler
wanders like a ghost
to the core.

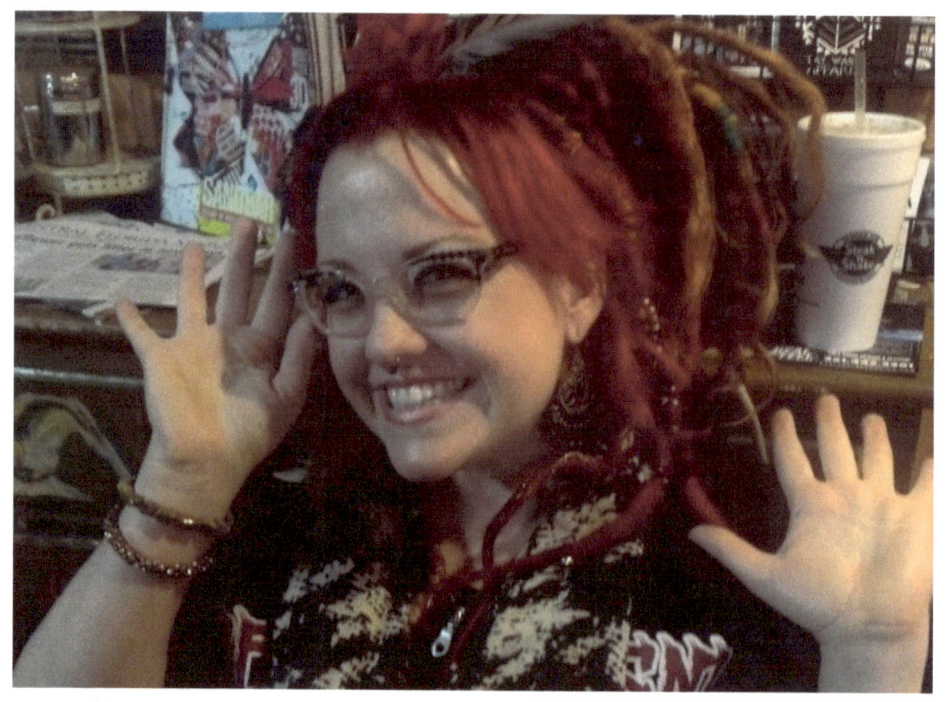

Everyone thinks
they're Mika Nism
full of spit and barley
hands sticky
with sprinkle glitter
and strands of crimson
a mouth full of arigato
spirits and ghosts
hawks and ravens
timba, timba, too.

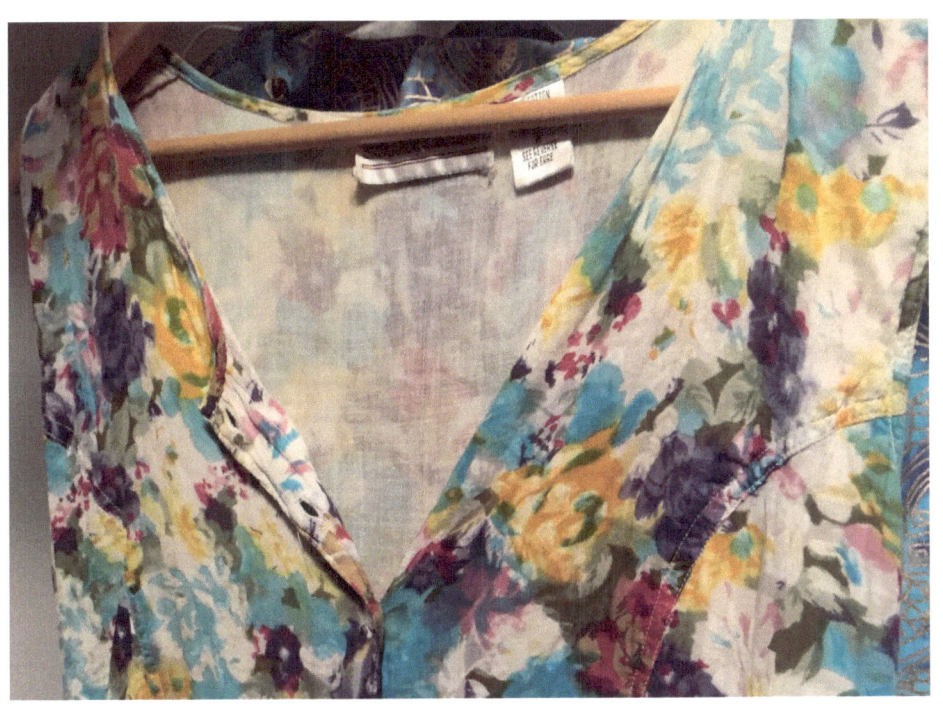

I saw your dress
hanging in the closest.
Empty. The two of us
longing for the warmth
of your skin.

Sometimes it's not how hard you pray
and
sometimes it is.

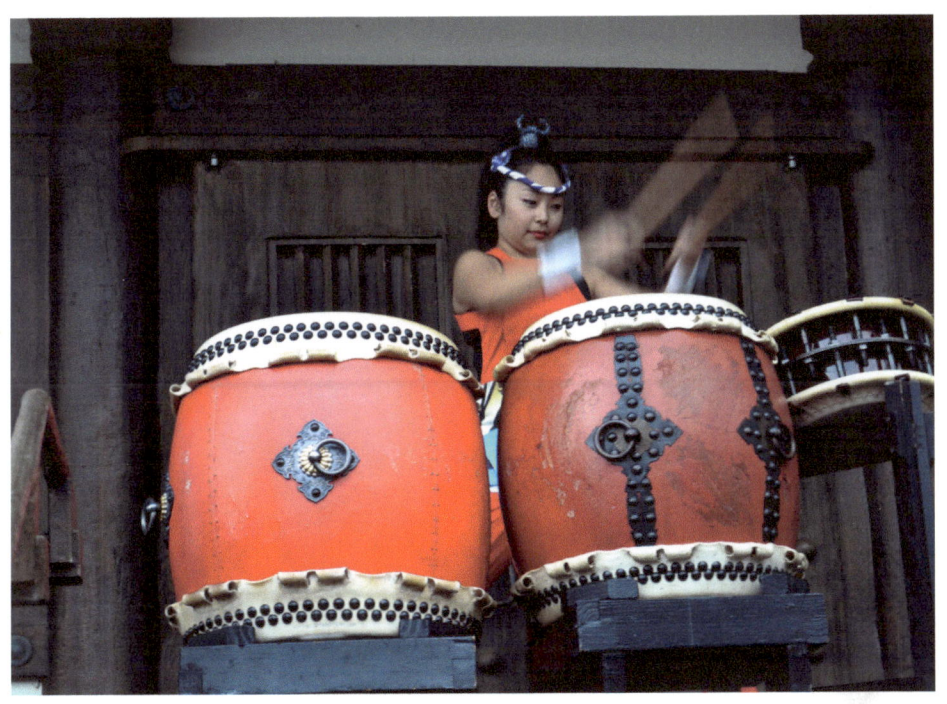

Amaterasu,
Goddess of the sun
dancing on an
empty barrel,
wood splinters
in her feet and
the scent of sake
on her breath,
Taiko, Taiko.

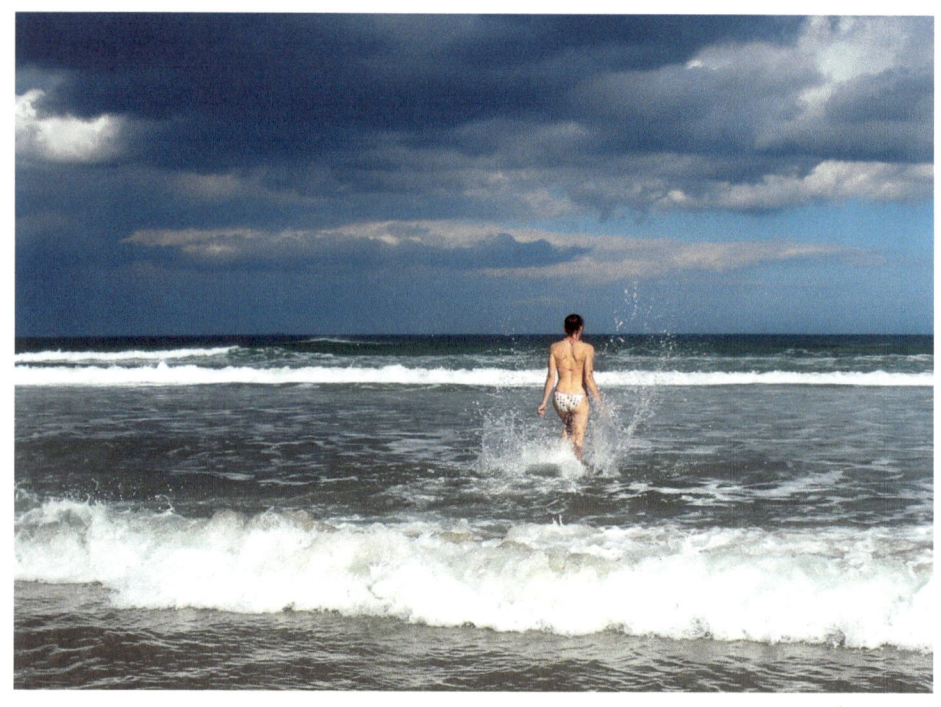

The sky turns blue then black,
the waves crash against the sand
in rowdy applause,
and the jelly fish,
those underwater angels,
the hem of their robes trimmed
in blue, float to the surface
to greet a mermaid returning home
from service above.

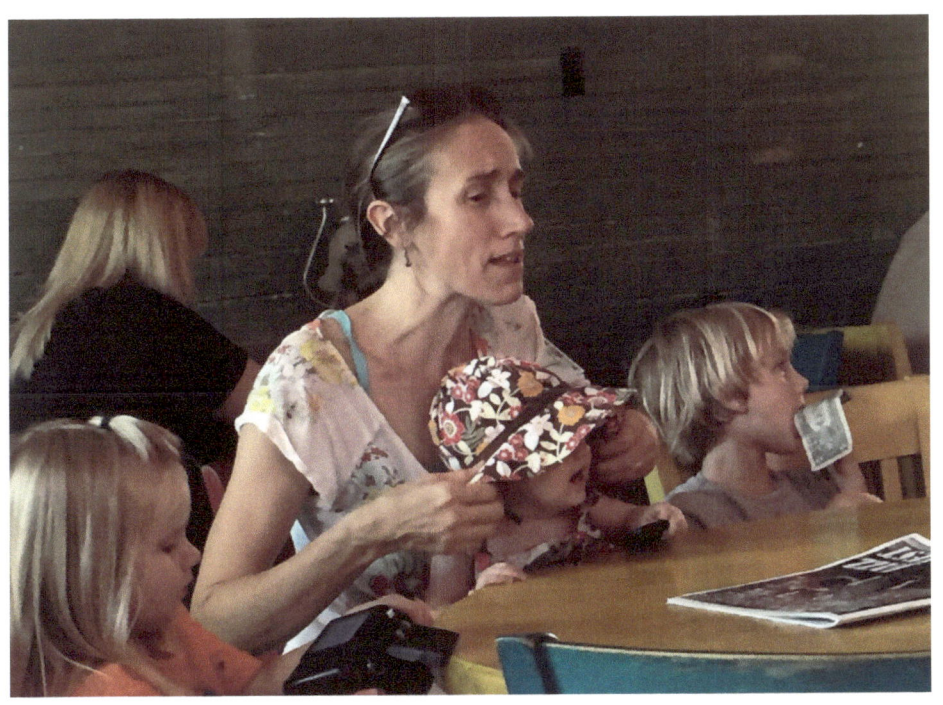

A good mom
teaches her children
how to handle money,
protects them from the
harsh rays of the sun,
and most importantly
how to set an appropriate
F-stop.

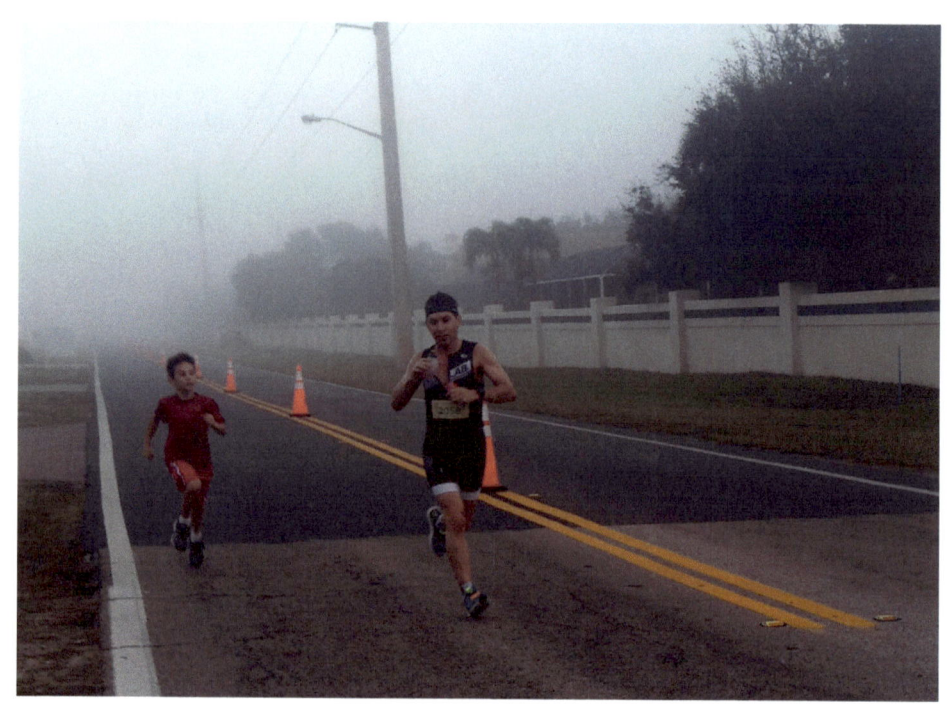

A father's gift to his son
is to Love and set a good example,
the child must simply
follow in his footsteps.

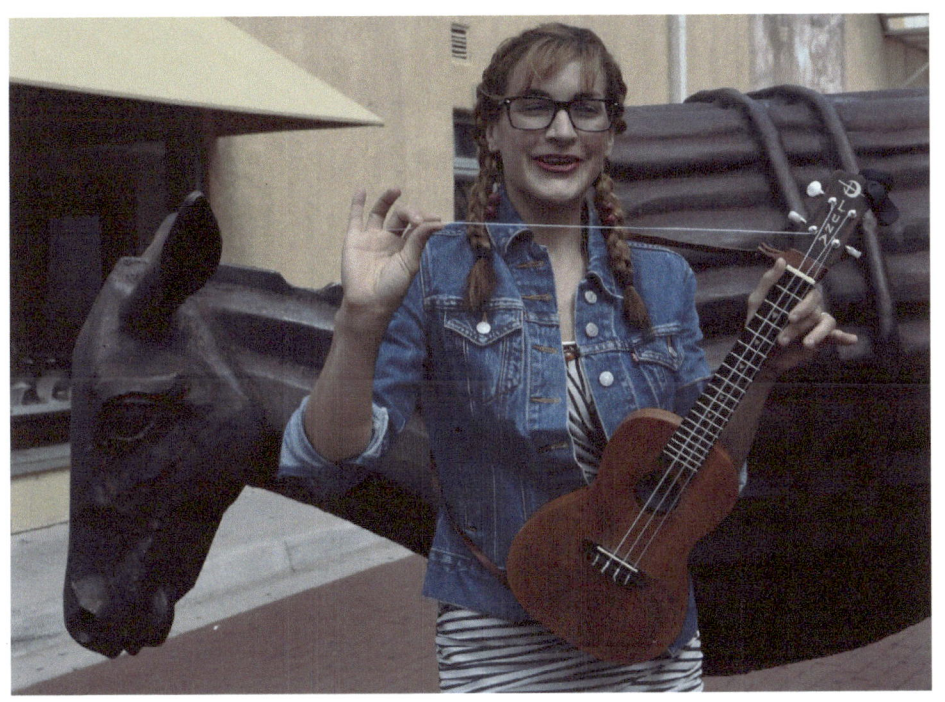

Her life turned out exactly
as she had hoped,
dresses sewn
from broken uke strings,
metal mules,
and the gift of a darling
rug weaver.

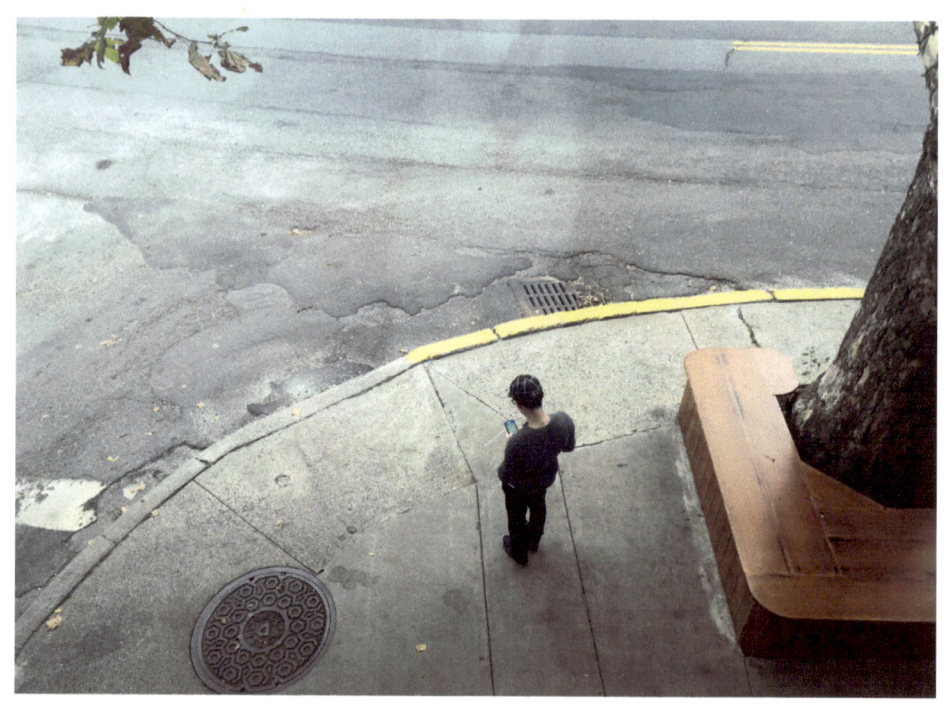

If you are always looking down
you'll never see an angel.

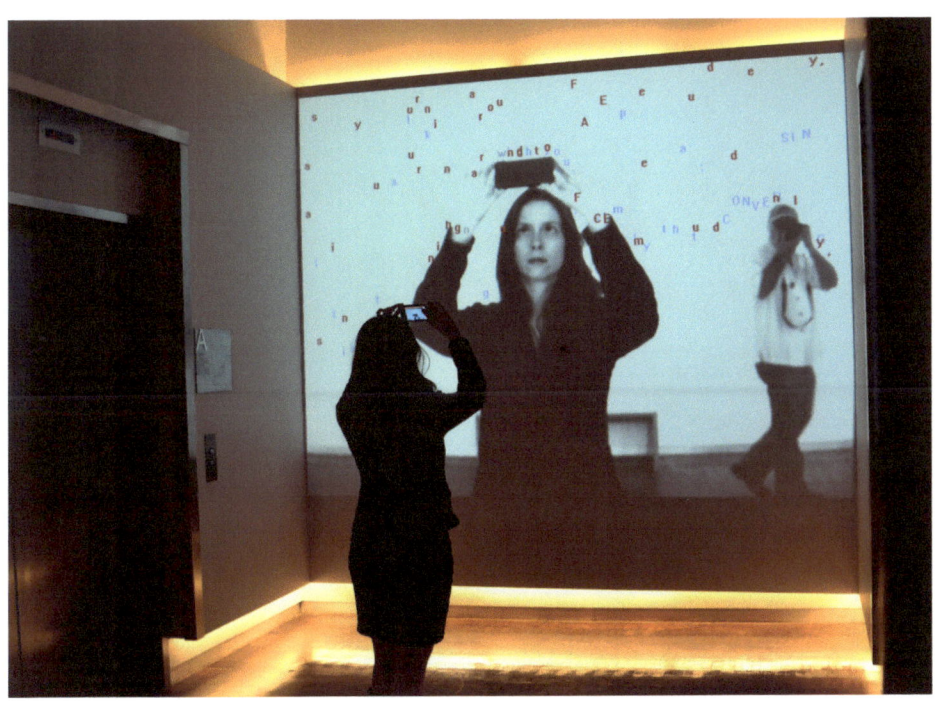

I saw you in passing
between the capital E
and the lowercase d
wondering if U noticed I.

We returned from Andromeda with gifts
for our great-great-great -grandchildren
and we passed by Mars,
and the Earth came into view,
the only river glistening in the sunlight
was the tears jettisoned from our eyes,
streaming down the burrowed canals
of our cheeks, and gathering like sacred pools
around the values of our grieving hearts.

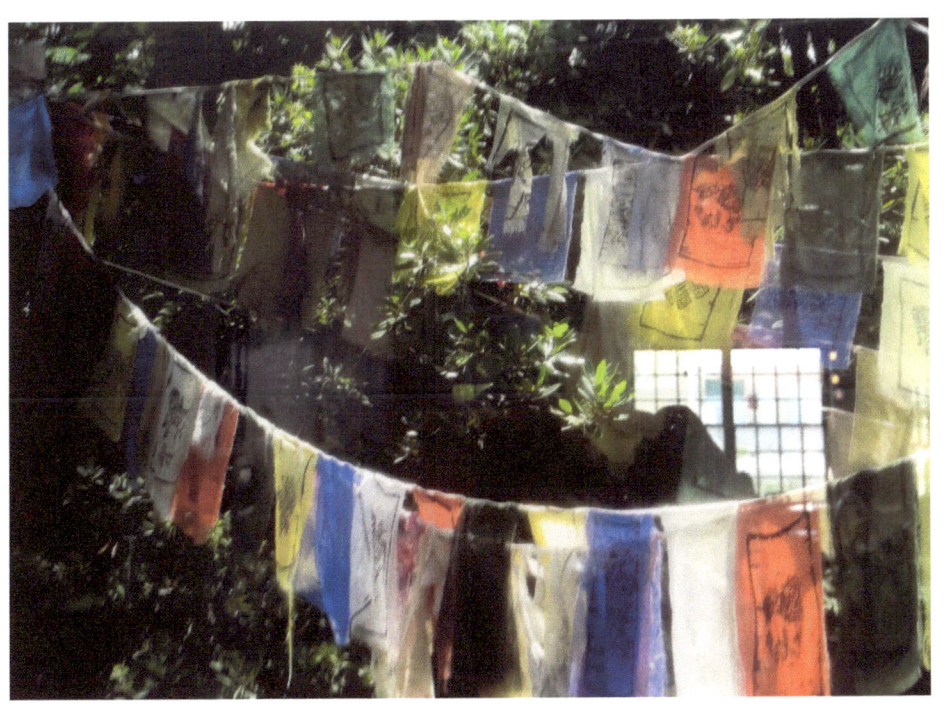

run up your flags
run up your prayers
tattered and torn
tethered and worn,
run them up.

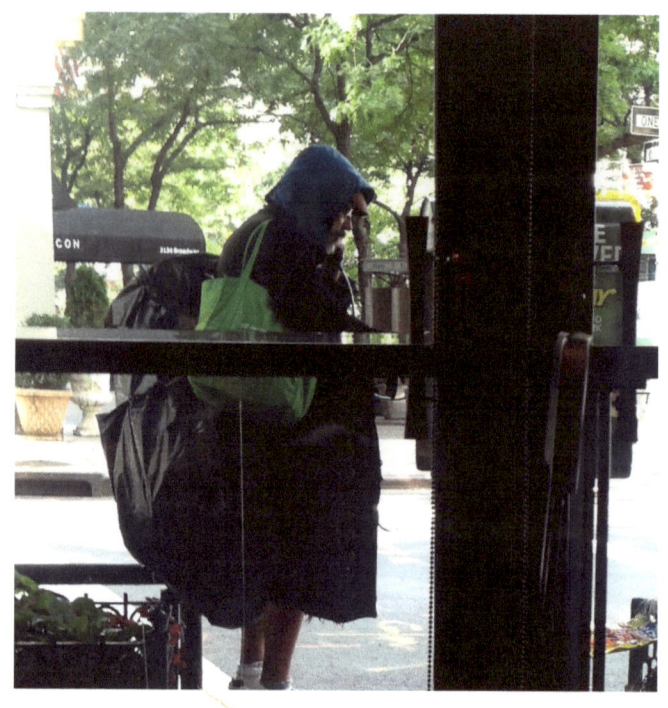

I saw a real man
drop an imaginary coin
into a pay phone
and have a spirited conversation
with someone who
hadn't yet noticed
that his phone was ringing.

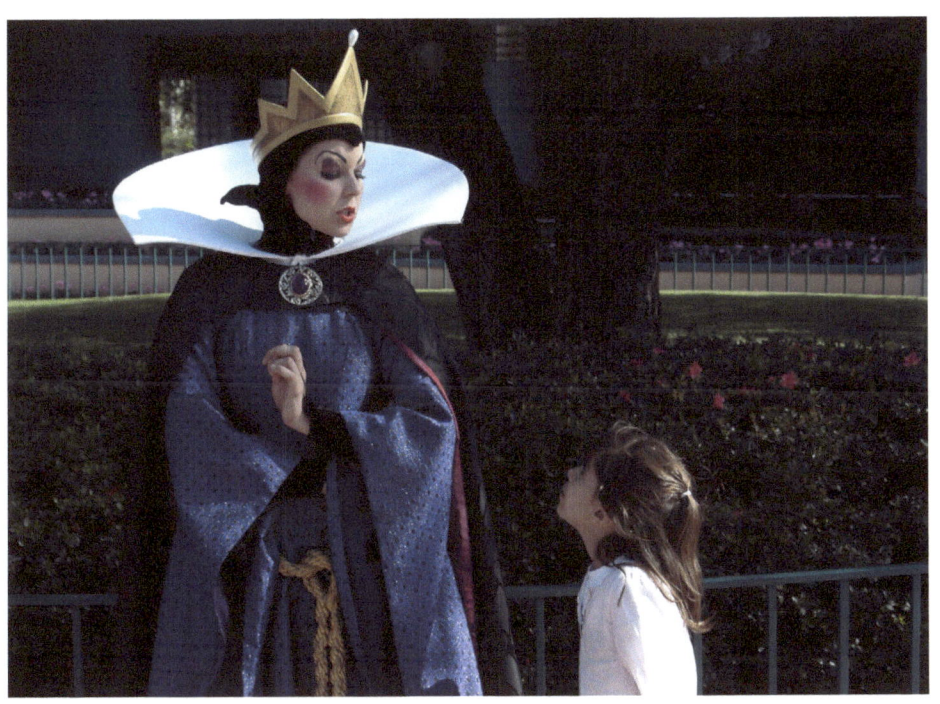

Now let me see if I have this right.
You want to know who made Me
the fairest in the land?

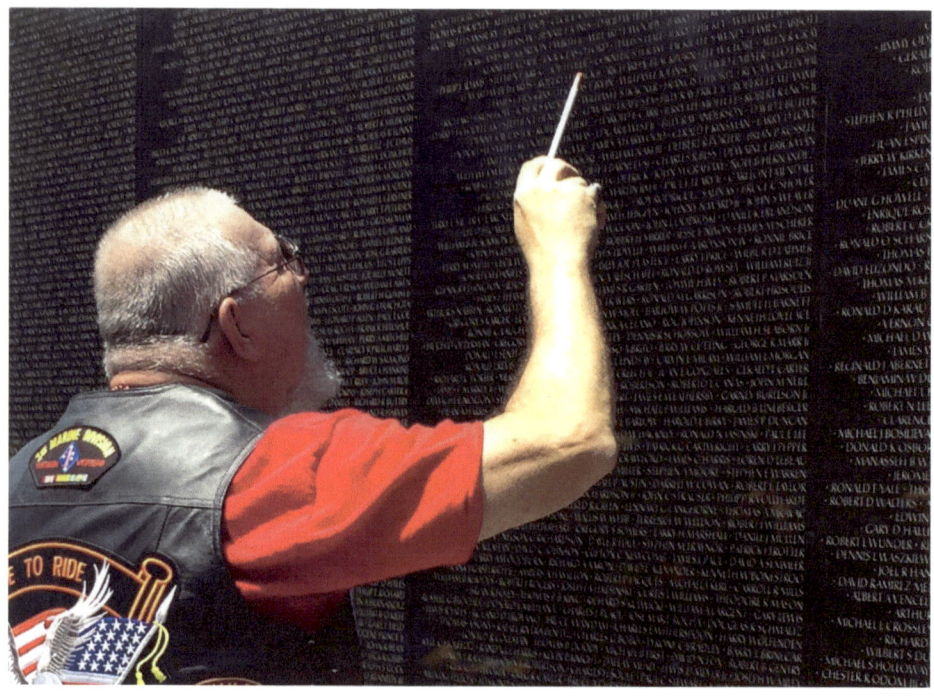

The first thing I notice
as I pass my hand over the names
of the dead etched into the granite
of the Vietnam Memorial is how
smooth the wall feels.

No rough edges to rip open old scabs.
No place for dripping blood to pool.
No cracks filled with petitions or prayers,
only smooth, cold stone,
low maintenance - high emotion.

Rows of solemn black seamless coffins
arced in a grotto where apparitions
of dead brothers and sisters stencil
memories upon the hearts of pall-bearers
struggling to carry the weight of recovery.

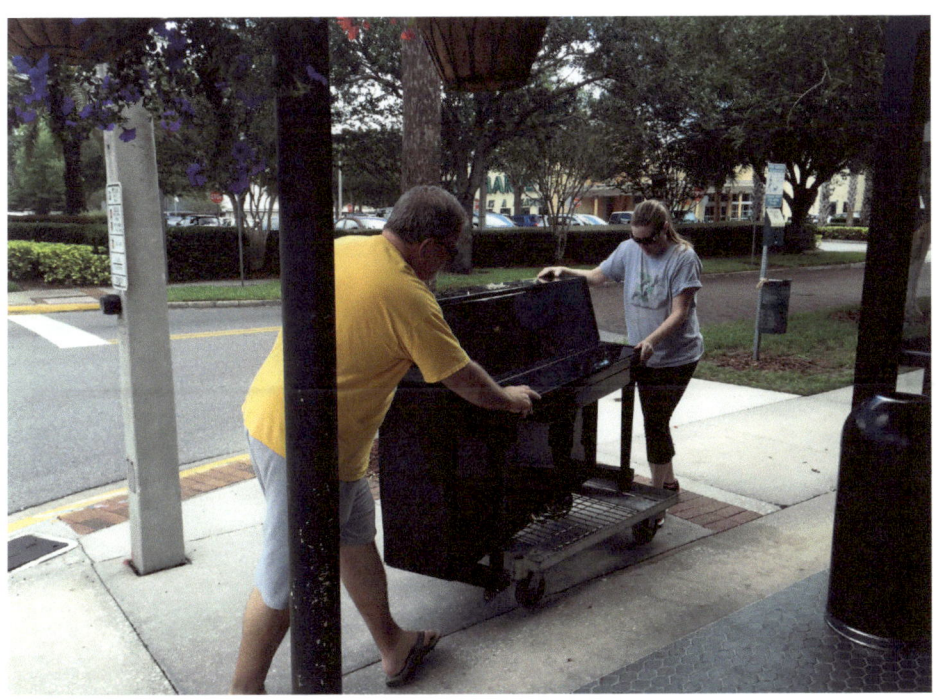

This is probably where it got its name,
Rock & Roll – this is the Roll part, the Rock
came later. I have no idea
where the Hoochie-Coo comes in.

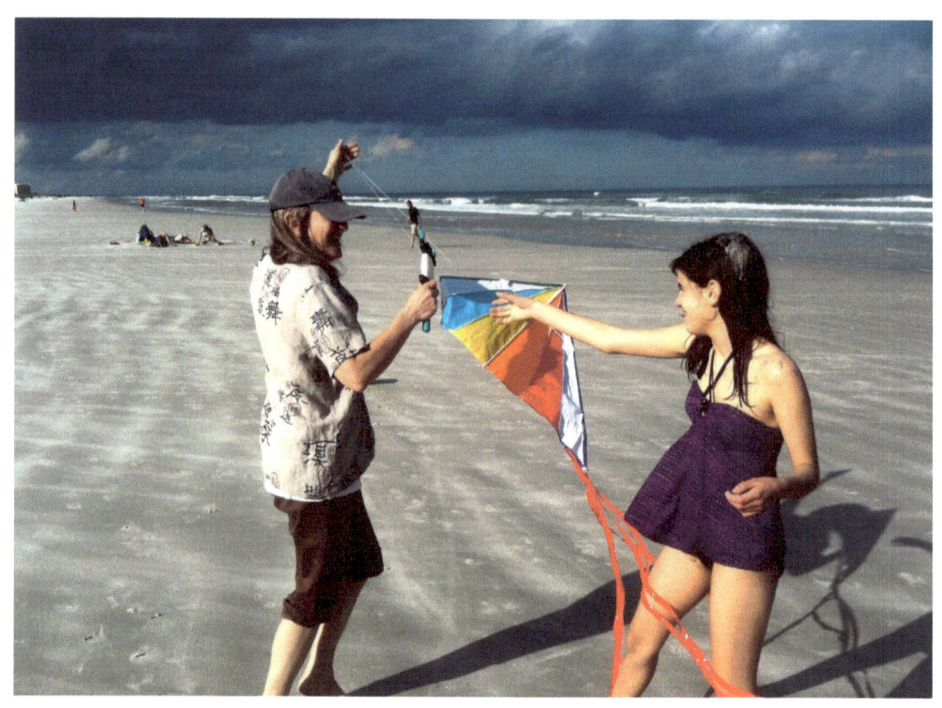

It was a Benjamin Franklin
kind of day,
or perhaps
Dr. Victor Frankenstein -
dark skies and green waters,
lighting rods and kites,
mom and daughter rising-up
amid raindrops and laughter.

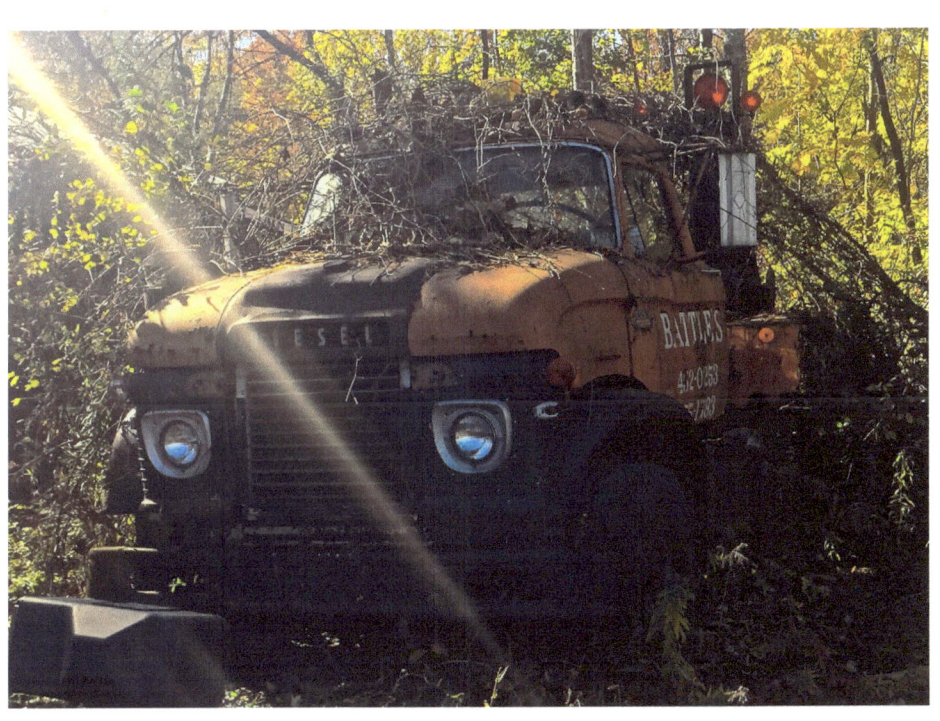

Regardless how old you feel,
how often you cover your flaws with vine,
get tangled up in blue,
light will seek you out
and illuminate your path.

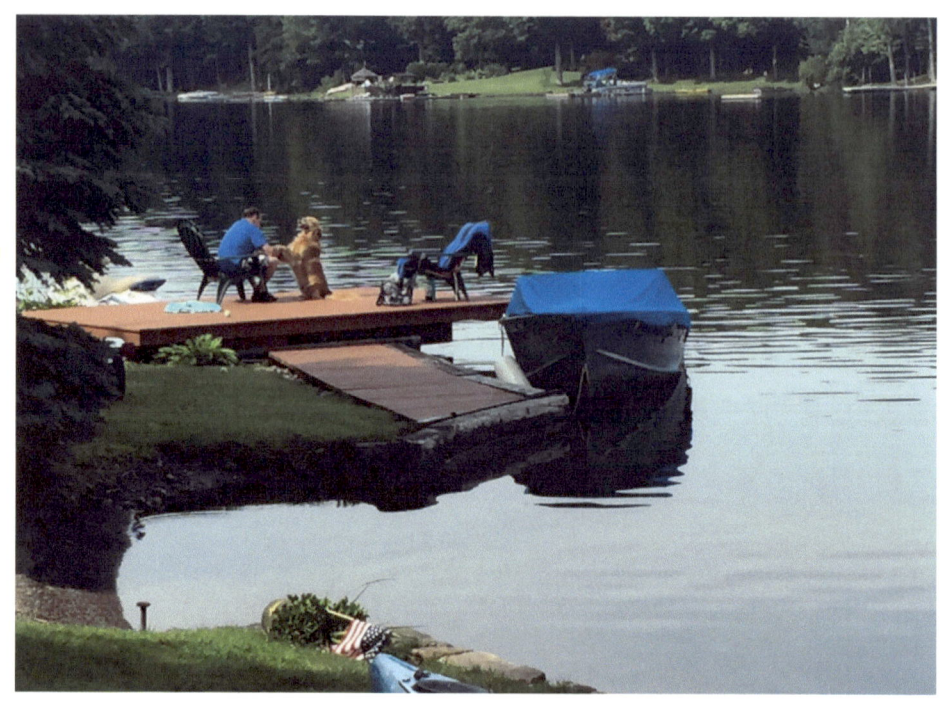

Old Blue.
You good dog you.

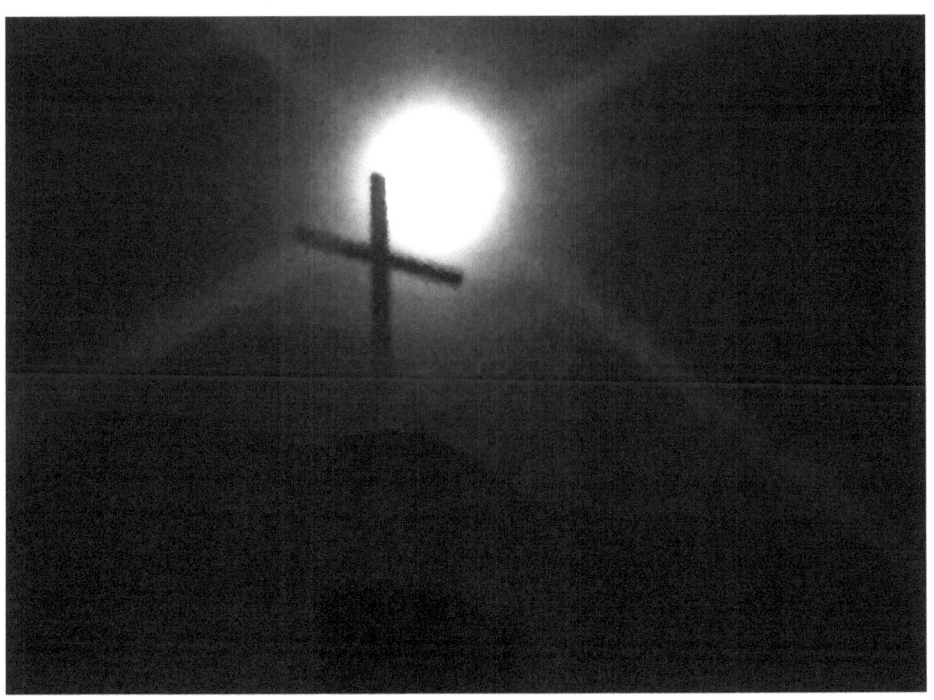

How many nights has the moon
passed behind the cross,
over the dish and the spoon,
or perhaps the chalice,
while the sacred cow
prepared to make its jump.

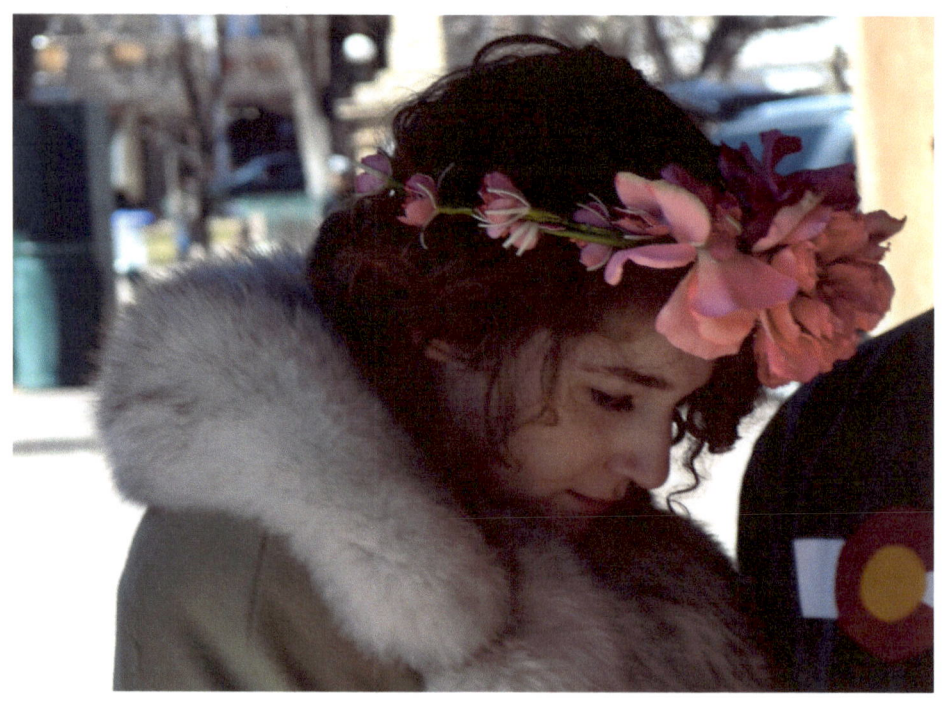

A rose by any other name dear Juliet,
is still a rose, still a vintage coat,
still a romantic poem and a silvery moon,
still a love song in major lift, a whisper of gratitude
and a prayer of Love and Peace.

www.ingramcontent.com/pod-product-compliance
Lightning Source LLC
Chambersburg PA
CBHW041114180526
45172CB00001B/247